THIS COLORING BOOK
BELONGS TO

A SPECIAL GIFT FROM

WITH LOVE

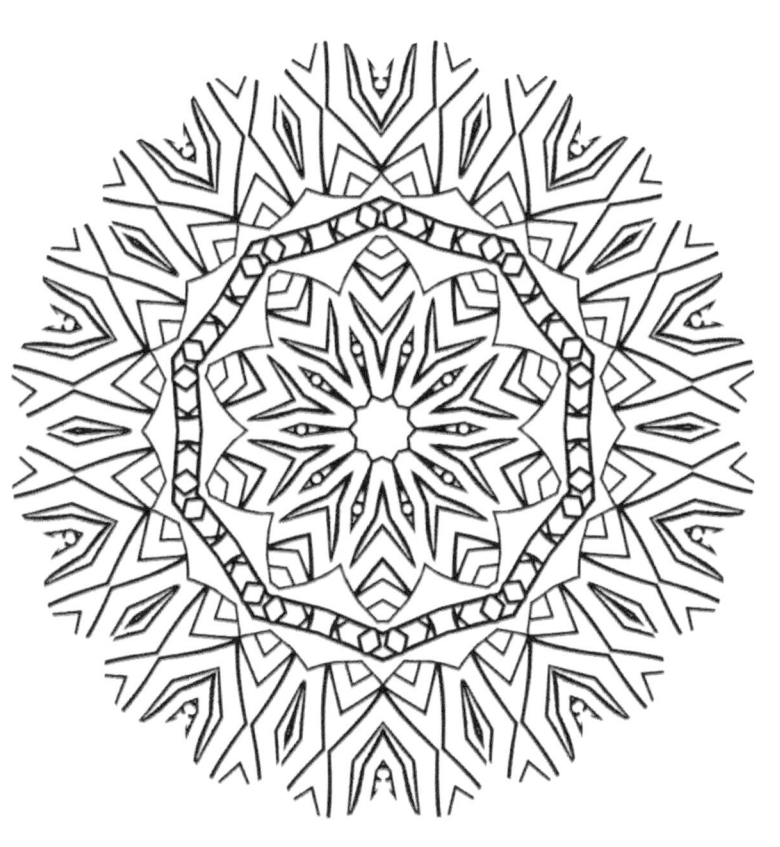

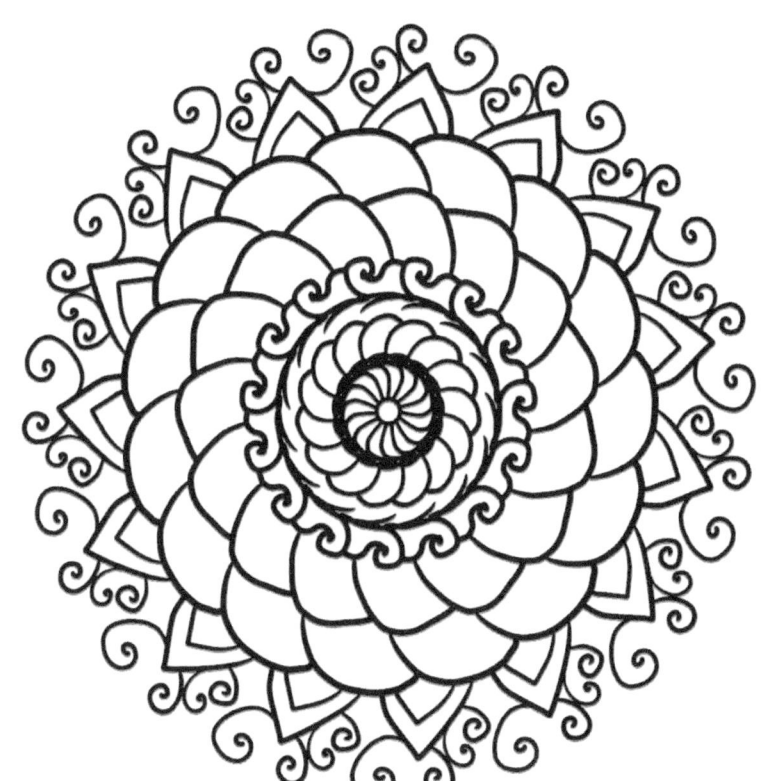

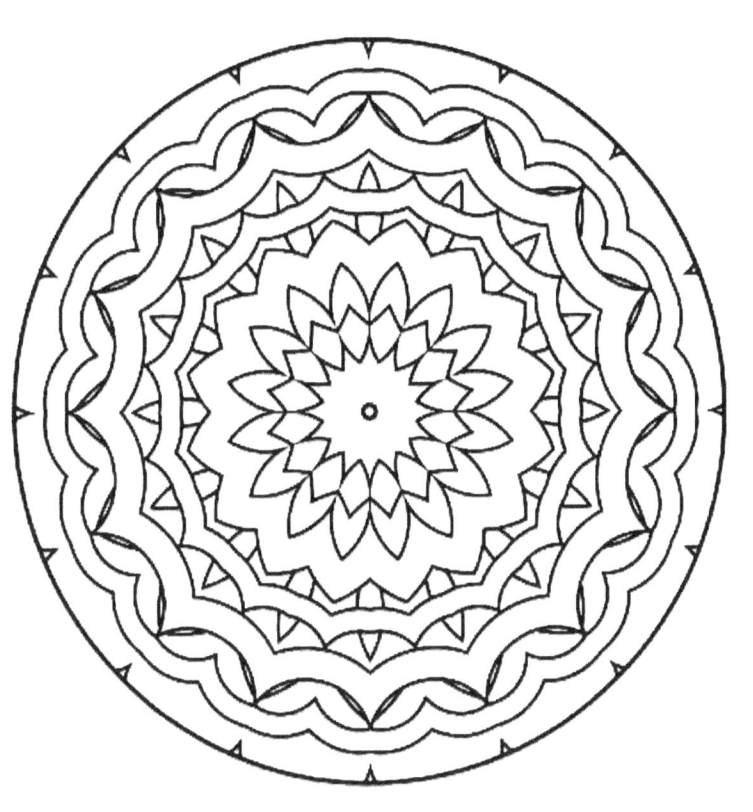

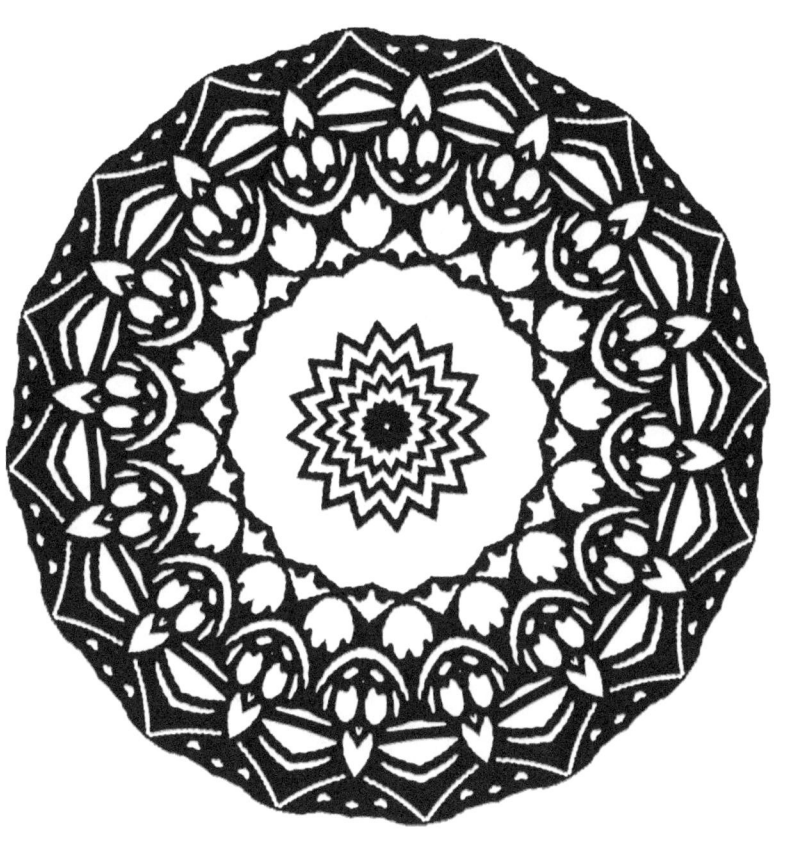

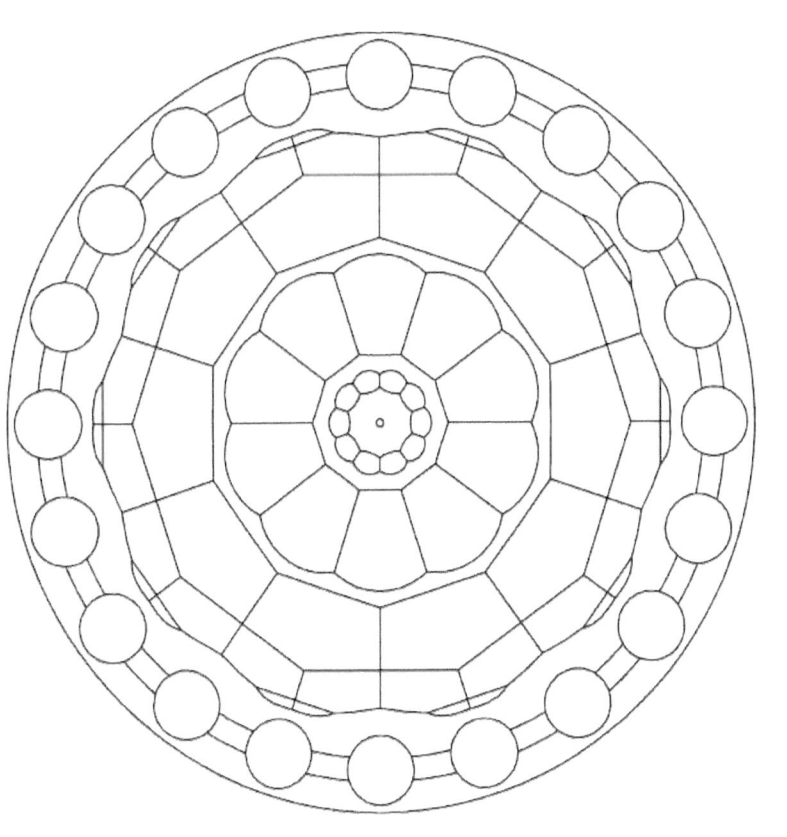

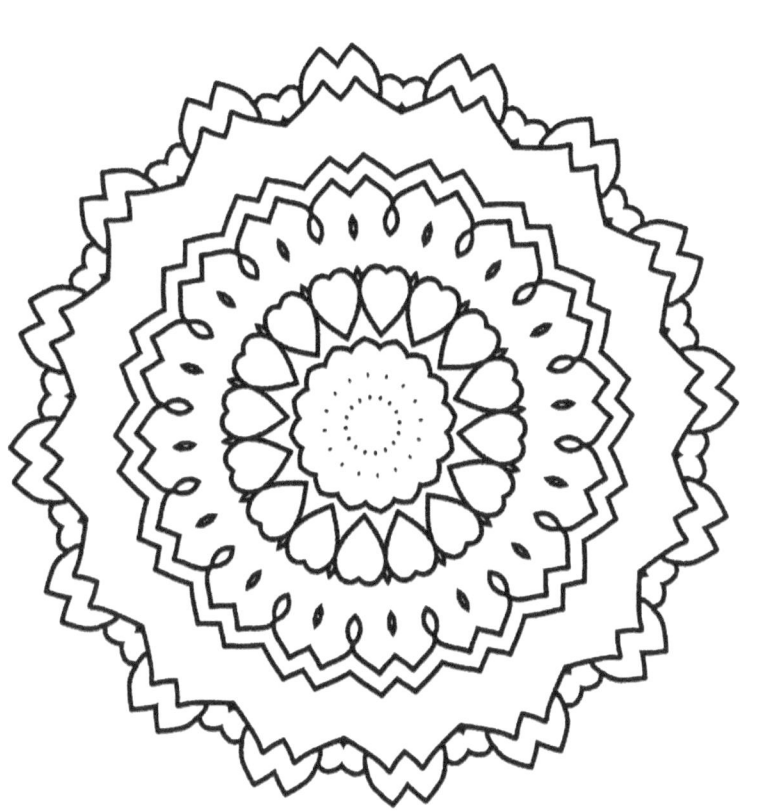

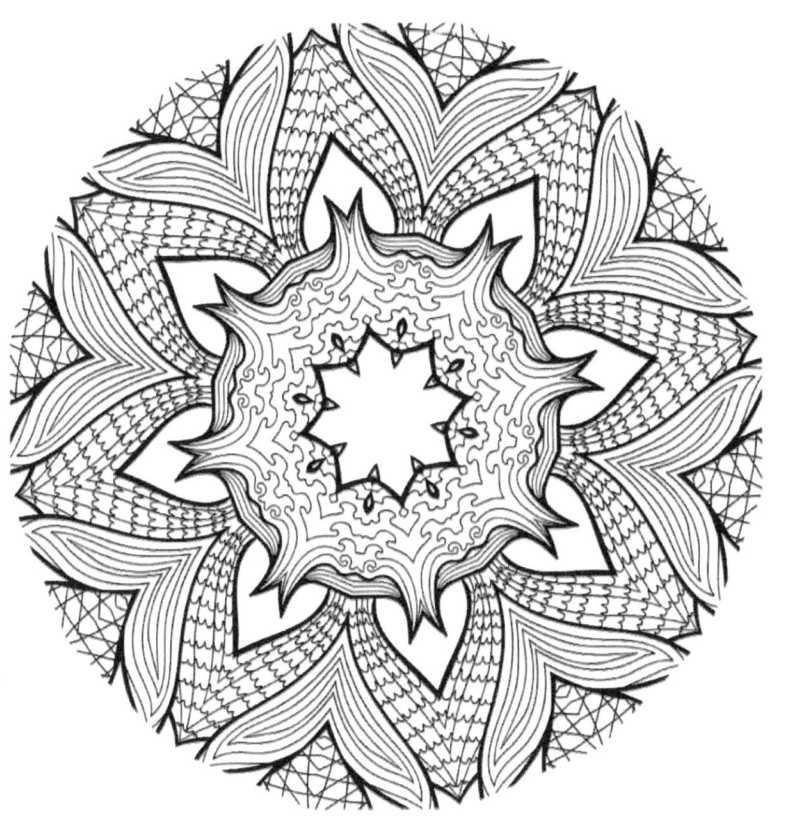

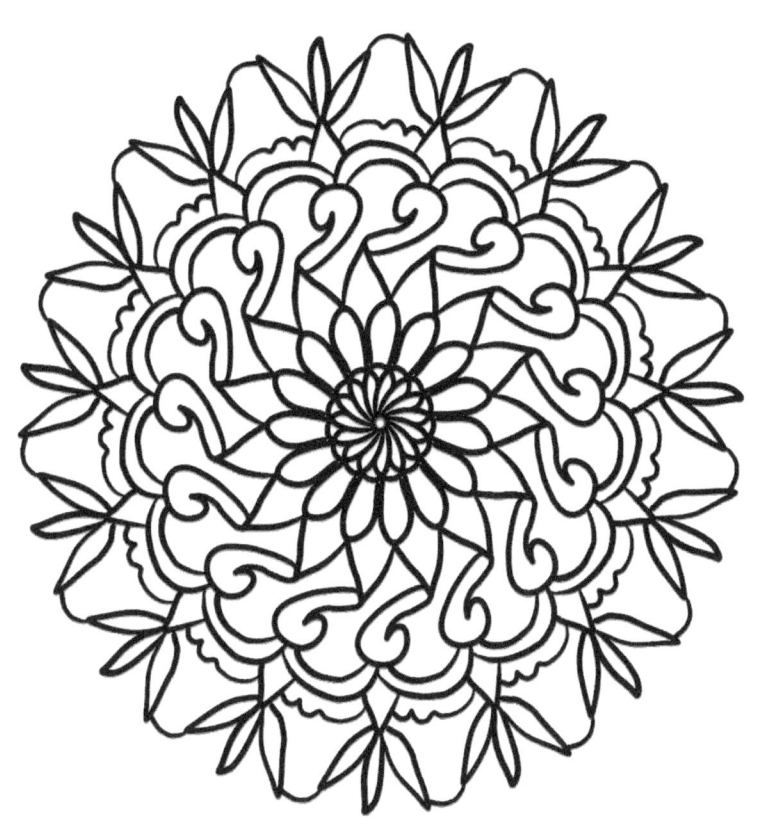

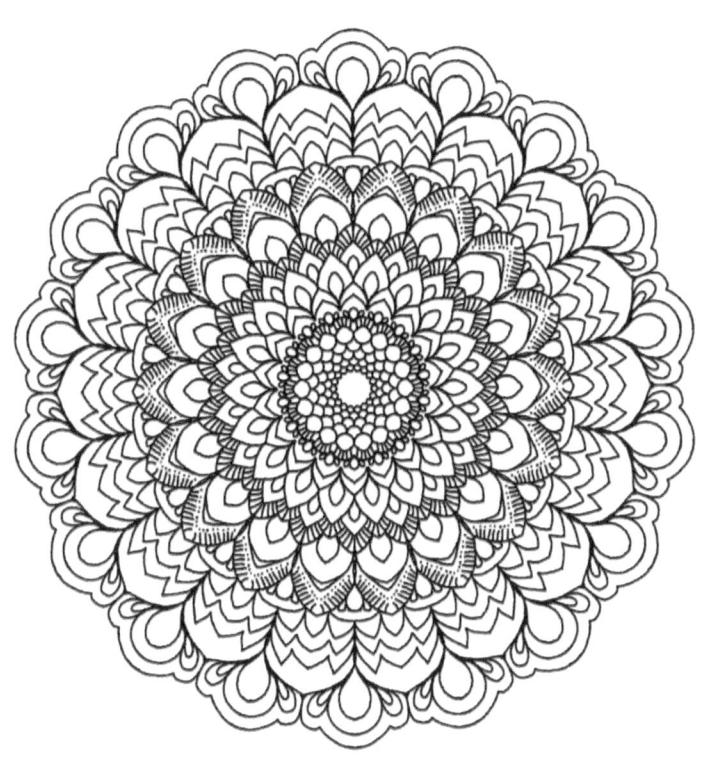

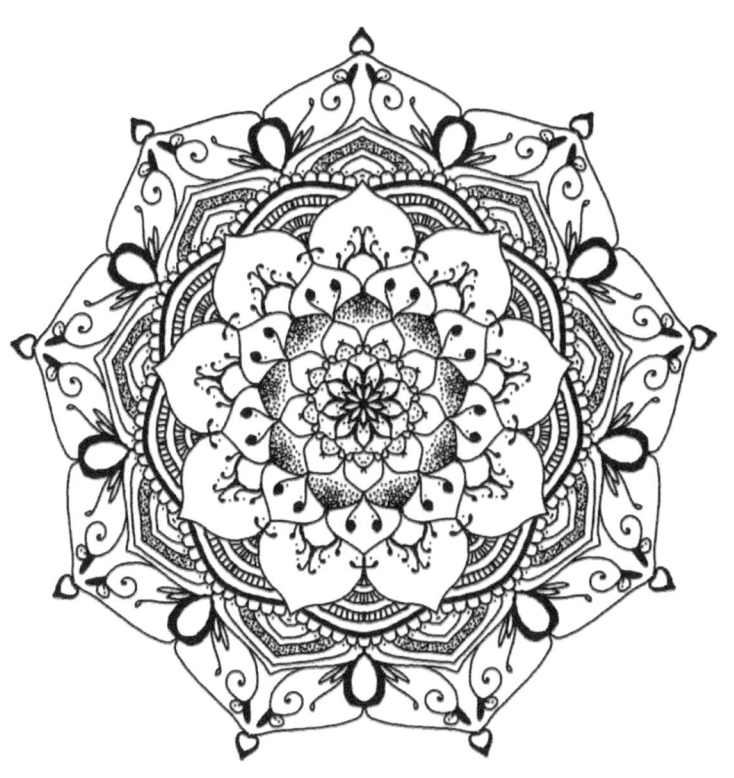

Color Testing Page

www.ingramcontent.com/pod-product-compliance
Lightning Source LLC
Chambersburg PA
CBHW020712180526
45163CB00008B/3051